INTIMATE LANDSCAPES

INTIMATE LANDSCAPES

THE CANYON SUITE OF GEORGIA O'KEEFFE

DANA SELF

UNIVERSE PUBLISHING

IN ASSOCIATION WITH THE KEMPER MUSEUM OF CONTEMPORARY ART & DESIGN

BOOK DESIGN BY YOLANDA CUOMO AND FRANCESCA RICHER

First published in the United States of America in 1997 by
UNIVERSE PUBLISHING
A Division of Rizzoli International Publications, Inc.
300 Park Avenue South
New York, NY 10010

97 98 99 / 10 9 8 7 6 5 4 3 2 1

Excerpts from Georgia O'Keeffe's correspondences are reprinted by permission of
the Stieglitz/O'Keeffe Archive in the Yale Collection of American Literature, Beinecke Rare Book
and Manuscript Library, and the Paul Strand Collection, Center for Creative Photography.
Excerpt from *Barren Ground* by Ellen Glasgow, copyright 1933, 1925 and renewed 1961, 1953 by the Richmond Society
for the Prevention of Cruelty to Animals, is reprinted by permission of Harcourt Brace & Company.
Excerpts from *Death Comes for the Archbishop* by Willa Cather, copyright 1929 by Willa Cather and
renewed 1957 by Edith Lewis and The City Bank Farmers Trust Co., are reprinted by permission of Alfred A. Knopf, Inc.
Excerpts from William Stafford, from "Level Light," "Now," and "Walking West," copyright 1977
by William Stafford, are reprinted by permission of the Estate of William Stafford.
Excerpts from *Beyond the Wall* by Edward Abbey, copyright 1971, 1976, 1977, 1979, 1984 by Edward Abbey,
are reprinted by permission of Henry Holt & Co., Inc.

Printed in Singapore

Library of Congress Catalog Card Number: 97-60136

contents

———

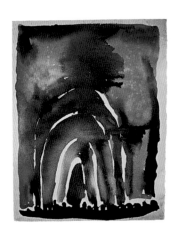

To my parents with love.

acknowledgments

The landscape of childhood is the one that remains in the soul. For Georgia, a real landscape would always be clean, untroubled, swept bare.[1] —Roxanna Robinson

Growing up in the Midwest, with the wide open skies and flat horizon of Kansas, has meant that the land of my childhood is the landscape that I miss when I am away from it. It is my favorite vista, what I think is most beautiful in a landscape—a seemingly endless horizon that meets an overwhelmingly large sky.

I am grateful to many talented people for their support of this project: Bebe and Crosby Kemper for their dedication to preserving the entire *Canyon Suite* for its importance in American art, and for giving me the opportunity to work with the paintings; The Enid and Crosby Kemper Foundation, and The William T. Kemper Charitable Trust; all my colleagues at the Kemper Museum for their work on the *Canyon Suite*, especially Walter Dietrich who enthusiastically encouraged me throughout, Michelle Bolton for her wizardly editorial expertise, and Dawn Giegerich for her registrarial finesse. Tom Dillingham suggested some of the poets, and C.J. Janovy and Steve Shapiro gave me comradely advice. Harold Veeser was an astute and clearheaded reader and offered insightful suggestions. Ultimately, Heather Keller at Universe edited the essay with a keen eye. Without all of these people, the project would not have been as joyous.

DANA SELF, Kansas City, Missouri, March 1997

introduction

memories of childhood are colored by where we grew up—the smell of the trees and the grass, playing by a creek, or running in a field. These elusive scents and gurgles sometimes inspire articulate responses. Yet for most of us, words fail. The nostalgic tenderness that characterizes the streets we walked or the landscape we left behind defies verbalization. A gifted few of every age discover a language—verbal, visual, musical—with which to capture the "remembrance of things past." Georgia O'Keeffe is certainly one; her paintings of the natural world provide us a rich visual language from which we may mine shared moments of solitude, reflection, and unbridled joy from the memory of meaningful places. We feel as if she is part of our American heritage and ingrained into our artistic consciousness. O'Keeffe excites emotional ownership, the same sensations that arise when we see once again, after a long absence, the home or landscape of our childhood.

Georgia O'Keeffe (1897–1986) was born November 15, in Sun Prairie, Wisconsin and appropriately, her earliest memory was "of the brightness of the light—light all around."[2] Light, and its effects on the natural world, influenced O'Keeffe's entire body of work. She was drawn to the out-of-doors and sought to interpret it intuitively throughout her artistic career. O'Keeffe's work remains a singular and iconoclastic voice in American modernism, yet her training was traditional: In 1905, she began her studies at the Art Institute of Chicago; she went on to study with William Merritt Chase at the Art Students League of New York in 1907;

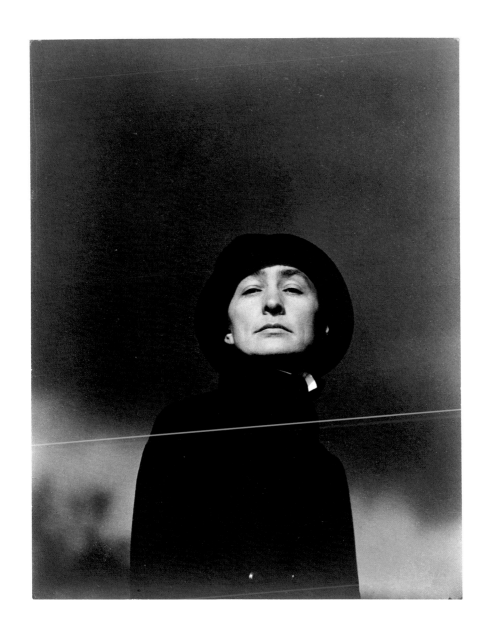

a year later she returned to Chicago to work as a freelance commerical artist until 1910; from 1912 to 1914, O'Keeffe taught in the public school of the Panhandle town of Amarillo, Texas; and from 1914 to 1916, she was a student of Arthur Wesley Dow, the head of the fine arts department of Teachers College at Columbia University. Of his influence she noted: "It was Arthur Dow who affected my start, who helped me to find something of my own . . . This man had one dominating idea: to fill space in a beautiful way."[3]

O'Keeffe returned to the Texas Panhandle in September 1916, to a town called Canyon, where she painted the 28 watercolors that constitute *Canyon Suite* while she was the head and lone faculty member of the art department at West Texas State Normal College. It was a return to a landscape that she loved, to a country that inspired her with its light, its open places, and its stupefying expanses. Landscapes like the Panhandle seem to require a peculiar devotion—to the sky and to the endless, almost frightening stretches of open land. O'Keeffe's own devotion, her affinity for the vast and the beautifully stark vista of the American Southwest, would characterize her artistic vision for the rest of her life.

Canyon's population was approximately 2,500, and while O'Keeffe had a distant relationship with the locals, she did meet, from time to time, kindred spirits whose love of the Texas plains was as powerful as her own. One such individual was a student named Ted Reid, with whom O'Keeffe had a close friendship, and to whom she gave the 28 watercolors of *Canyon Suite*. Ted Reid's granddaughter subsequently brought the watercolors to gallery

owner and O'Keeffe admirer, Gerald Peters, who helped ensure that the suite stayed together.

The watercolors portray canyon landscapes, the myriad changing colors of the natural world, and the dominant voice of the Texas Panhandle—the sky. O'Keeffe's devotion to and interpretation of the sky is personal yet has precedence in American painting. Art historian Barbara Novak has noted about nineteenth-century art:

> Sky in American art has a clearly identifiable iconography. The painters of a culture deeply imbued with transcendental feeling found in it the purity of renewal, the colors of hope and desire, heavenly reflection of earthly nostalgias . . . As the source of light, spiritual as well as secular, the sky relieved absolutism with infinite moods, unchanging ideals with endless process.[4]

O'Keeffe's paintings accomplish this by allegorizing her private pleasure with the endless variation of light. Her fascination with the sunrise, sunset, and the horizon is evident in such works as *Light Coming on the Plains*, in which a shimmering patch of iridescent light blooms in the middle of a blue sky, and flickers above a dark swatch of land; and in *Canyon Landscape*, the sky hovers above a sweeping canyon view, and a dark, elongated bead of paint suggests a storm moving in across the sky.

These abstract images also demonstrate the continuing influence of her former teacher, Arthur Wesley Dow, who wrote, "It is not the province of the landscape painter, for example, to represent so much topography, but to express an emotion; and this he must do by art."[5] In *Across the Plains* and *Blue Hills*, O'Keeffe intuited nature's luminous infinity with only a

few colors. These paintings are emotionally charged souvenirs of her experience—profound and transient moments in time that will never be repeated the same way, suggesting nature's nostalgic power to engender longing in us.

*i*n the *Canyon Suite* landscapes there is nothing—no people or buildings—that could insinuate any constraints of class, economics, or ideology. These paintings are not a stage for human activities, nor an attempt to inscribe the world, but rather a bid to pictorially characterize O'Keeffe's deeply ethereal and corporeal responses to the land. Even the paintings that indicate a figure, a door, or a train are painted so loosely and amorphously as to suggest that they may trickle into something else. O'Keeffe offers spectacular visions by which, in a few strokes of the color-loaded brush, wide vistas open up before us. Like O'Keeffe, we may feel enlightened and enraptured by the landscapes' panoramic splendor. To borrow art historian T. J. Clark's words, the *Canyon Suite* is "the private spectacle of nature,"[6] and we are lucky enough to share it. Ultimately, O'Keeffe painted more than 50 watercolors during her time in Canyon. After leaving Canyon for New York, O'Keeffe was reflective of her years in Texas: "I lived on the plains of north Texas for four years," she wrote in 1919. "It is the only place I have ever felt that I really belonged—that I really felt at home."[7]

In O'Keeffe's letters from her time in Canyon, she describes the Panhandle with a lyrical and heartfelt response that reverberates, not only in her own early abstract imagery, but in the verbal imagery of many novelists, poets, and essayists. Ironically, however, in 1916

O'Keeffe writes, "Words and I—are not good friends at all except with some people."[8] She seemed to feel uneasy with words; she expressed herself best in color and form, and through paint sought harmony, parlay, human convergence. Yet, O'Keeffe's unrestrained watercolors, painted out-of-doors, tap into a connection with nature that others seem to share. By choosing the natural world of the Southwest, and inscribing it in her own visual language, O'Keeffe retailored a rich visual history in American art on her own terms.

The diverse poetry and prose selected to accompany the *Canyon Suite* watercolors embody the well-lived experience of the American landscape O'Keeffe communicates through her paintings. For example, Willa Cather and O'Keeffe share a similar longing to wholly communicate their passion for the land and sky. From time to time, O'Keeffe's candid letters from Canyon describe her surroundings in language remarkably similar to Cather's accounts of western Nebraska or New Mexico. Other American poets and essayists included in this book create images that invoke a spectacular sunset or the shifting light of day, as insightfully as do O'Keeffe's unusual colors and abstract shapes. All of these writings may encourage us to share O'Keeffe's painted declaration of enchantment with the Panhandle. The affinities between O'Keeffe's watercolors in this seminal collection and these poems and prose passages may broaden our appreciation of O'Keeffe's visionary devotion to depicting, in an abstract language, the effect of light on the land and the human spirit.

much of Willa Cather's prose is colored by her exhilaration with light. Cather (1873–1947) was born in Winchester, Virginia, and moved to the plains of western Nebraska as a girl. Cather and O'Keeffe share similar visions and express themselves with similar written and painted imagery. Passages in Cather's *My Ántonia*, published in 1918, acclaim western Nebraska's stark beauty and its unforgiving qualities; in *Death Comes for the Archbishop* (1927), New Mexico's landscape seems to have its own voice in the narrative. Cather's descriptions of the sky in each novel echo O'Keeffe's own letters and her *Canyon Suite* watercolors. For instance, in *Death Comes for the Archbishop*, Cather writes, "The landscape one longed for when one was far away, the thing all about one, the world one actually lived in, was the sky, the sky!"[9] In a letter dated 11 September 1916, O'Keeffe remarks to her friend Anita Pollitzer, "It is absurd the way I love this country . . . I am loving the plains more than ever it seems—and the SKY—Anita you have never seen SKY—it is wonderful—."[10] Their observations of the night sky during a lightning storm are also markedly parallel. Cather writes, in *My Ántonia*, "the lightning broke in great zigzags across the heaven, making everything stand out and come close to us for a moment." [11] In a 1916 letter to Alfred Stieglitz, O'Keeffe observes, "The Eastern sky was all grey blue . . . sometimes sheet lightning with a sharp bright zigzag flash across it—."[12]

Cather and O'Keeffe both defied typical feminine social practice of the early twentieth century. They were ambitious women who were devoted to their careers and led nontraditional lives. They even seemed to dress alike. According to Doris Grumbach, "Her university classmates would remember the Willa Cather who was masculine, brash, and

unconventionally dressed."[13] One of O'Keeffe's students remembered her as such: "Oh, she wore black. Black, black, black! And her clothing was all like men's clothing."[14] Both women were passionately devoted to their medium. Cather stated, "nothing mattered . . . but writing books, and living the kind of life that made it possible to write them."[15] Similarly, O'Keeffe decided when she was a young girl that she was going to be an artist and her devotion to her art never wavered throughout her life.

While it seems that, at the time, neither woman regretted leaving her stark countryside, the fact remains that both memorialize those places in eloquent, loving language. Cather and O'Keeffe were also ultimately drawn back to the Southwest. O'Keeffe's early experiences in Amarillo and Canyon opened her senses to the Southwest. Her early experience of New Mexico came in 1917 when she traveled to Colorado with her sister Claudia during her Canyon years. Of New Mexico, Cather writes, "I go everywhere. I admire all kinds of country. . . But when I strike the open plains, something happens. I'm home. I breathe differently. That love of great spaces, of rolling open country like the sea—it's the grand passion of my life. I tried for years to get over it. I've stopped trying. It's incurable."[16] O'Keeffe would also later remark about New Mexico, "From then on, I was always on my way back."[17] The light, land, sky, and feel of the American Southwest resonate in each woman's art.

An emotional connection to the American landscape has inspired other writers who praise the land in diverse metaphors. Images conjured by language such as, "In one stride night then takes the hill" (William Stafford), "The puffball appears on the hill like the brain of an

angel" (Nancy Willard), and "Had not the land entered their souls . . . " (Ellen Glasgow) encourage us to see the land in visionary and sometimes abstract ways, just as do O'Keeffe's paintings. Her work evokes similar visual metaphors as the poems and prose of writers who know and love this land. It suggests the profound effects of experiencing the natural world through all our senses. For instance, Edward Abbey wrote extensively on the desert Southwest, using words to paint the vivid, colorful landscapes he witnessed. His prose uncannily echoes O'Keeffe's colors and images. In particular, passages from *Beyond the Wall: Essays from the Outside* suggest that Abbey could have been staring into the same startling night sky as O'Keeffe when she painted *Abstraction*: "gold fading into violet as it floats across the sky."[18]

*V*isual fascination with the land has an established heritage in American art. In nineteenth-century America, landscape painting was the dominant vehicle of visual expression, and American landscape artists expressed the romanticism the land embodied for them. From the Hudson River School artists' (Thomas Cole, Frederic Edwin Church, Albert Bierstadt) rapturous exclamations of nature's spirituality, to the quiet, contemplative works of Luminists Fitz Hugh Lane and Martin J. Heade, we find a preoccupation with nature and its meanings. The influence of Ralph Waldo Emerson's transcendentalism, which proposed knowing and understanding a spiritual reality through intuition, helped stitch an independent and spiritual concept of nature to the landscape.[19]

According to Barbara Novak, in the nineteenth century, "each view of nature, then carried with it not only an esthetic view, but a powerful self-image, a moral and social energy that could be translated into action. Many of these projections on nature augmented the American's sense of his own unique nature, his unique opportunity . . . "[20] In Canyon, O'Keeffe immersed herself in a life of self-discovery and oneness with nature. Not only do the *Canyon Suite* watercolors define her seemingly endless enchantment with the land and sky and all their unique stations, but also reflect her self-exploration and early independence from larger social groups. Because she was not associated with a defined school of artists when she painted the intimate *Canyon Suite*, this painted celebration of nature is her own independent, private, and even secret memorial. Her secular, pictorial celebration bears witness to a devotional, abstracted nature, rather than a representational or religious one, as demonstrated by Hudson River School painters.

The *Canyon Suite* watercolors are among the first abstract works done by an American artist. Arthur Dove's *Abstractions* from 1910 were the harbingers of work to come, yet, according to O'Keeffe scholar, Charles Eldredge, Dove never exhibited them.[21] Working in isolation in remote Canyon, O'Keeffe produced these early abstract iconoclastic paintings and, knowingly or not, established herself as an American artistic visionary. Unlike earlier nineteenth-century American landscape paintings, in O'Keeffe's there exists no hierarchical organization of space. The watercolors' loosely applied paint and startling colors indicate O'Keeffe's unwillingness to impose any rigid structure on the natural world. O'Keeffe was, however, influenced by some artistic theories of the time.

Her lyrical abstractions, so derived from nature, seem also to embrace the artistic theories of artist Wassily Kandinsky whose book, *Concerning the Spiritual in Art*, she had read. Kandinsky wrote,

> The forms, movement, and colours which we borrow from nature must produce no outward effect nor be associated with external objects. The more obvious is the separation from nature, the more likely is the inner meaning to be pure and unhampered.[22]

For instance, the dusky purple, red, and blue from the abstract painting, *Tree*, affirm O'Keeffe's symbiotic relationship with color, which she used to express how nature made her *feel*. Shades of aubergine surrounded by dots of red celebrate the tree as a unique object, tenuously anchored to the real world. Following Kandinsky's admonition, O'Keeffe's color choices suggest that representing her tenderness for the tree is more powerful than direct depiction. Through solitary communion with the environment of the Texas Panhandle, she intuited the natural world with small pools of paint, the conduit for a powerful individual expression. According to Charles Eldredge,

> Through their pictorial imaginations, O'Keeffe and Dove transported themselves from the mundane plane to a God's-eye view, witnessing the world wheeling in the infinite. Through their abstractions they sought to capture the vital essenses of nature, a unity of micro and macro, of man and universal spirit. [23]

In every *Canyon Suite* watercolor we sense O'Keeffe's unambiguous joy in the land and sky before her. As artistic intermediary, she discloses the emotional and psychological effects that nature may excite in us. Cleaving herself from the mainstream for those two years in Texas, O'Keeffe enjoyed an unusual freedom, both professionally and personally, to express herself exactly as she wished. These land and sky paintings, unblemished with the human form, celebrate isolated and even fragmented moments in time; time passes through the shifting colors of the days. The paintings more eloquently say what she wrote in her fragmented letters to friends back East. What lexicon could provide words enough to describe the changes of light, color, mood, and even paint application from painting to painting? O'Keeffe's art stands as one of our best essays on mutability and transcience, the sharpest explanations of a place where the vista is practically nothing but land and limitless sky.

DANA SELF, CURATOR
The Kemper Museum of Contemporary Art & Design

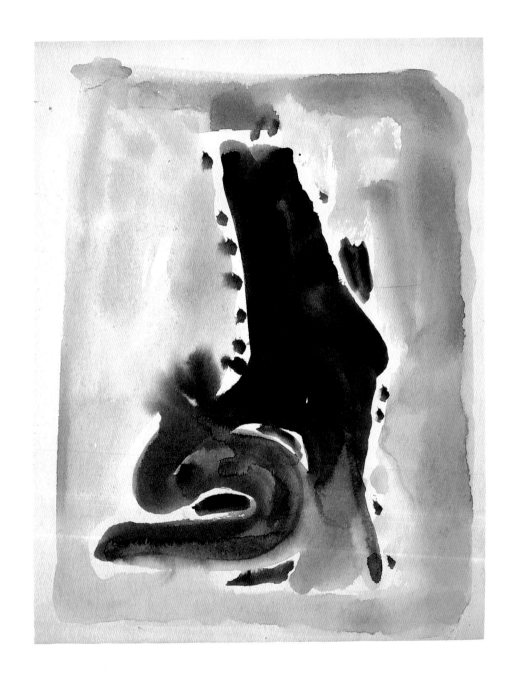

There is no "must" in art, because art is free.

———

WASSILY KANDINSKY

portrait – w

The mesa plain had an
appearance of great antiquity,
and of incompleteness;
as if, with all the materials for
world-making assembled, the Creator
had desisted, gone away and left everything on
the point of being brought together,
on the eve of being arranged
into mountain, plain, plateau.
The country was still waiting to be
made into a landscape.

WILLA CATHER

dark mesa

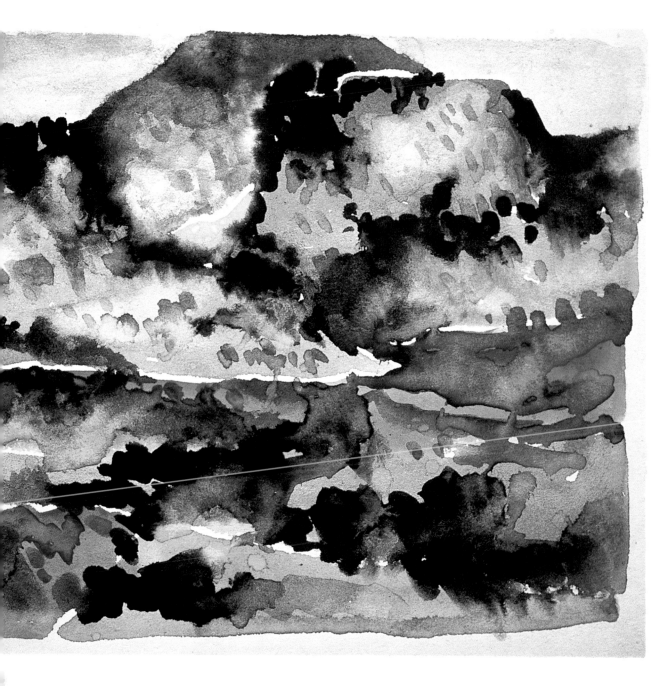

The fire opal has a single point of intense scarlet, melting into pearl; the clear evening sky is like this when from the sunken sun the red-orange light grades away through yellow and green to steel-gray.

ARTHUR WESLEY DOW

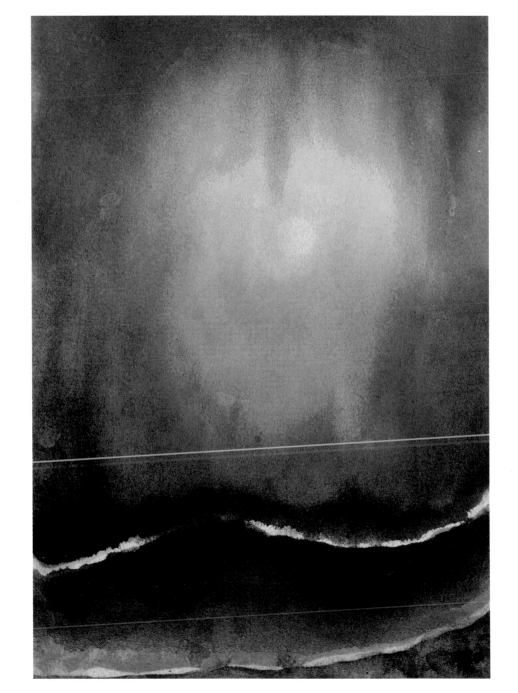

The plains are very wonderful now—like green gold
and yellow gold and red gold—in patches—and the distance
blue and pink and lavender strips and spots—May
sound like a Dow canyon—but really it's wonderful—specially in
the evening—I usually go alone—Yesterday rode home
on a hay wagon—no it was clover . . .

————

GEORGIA O'KEEFFE TO ANITA POLLITZER
Canyon, Texas, 1916

autumn on the plains

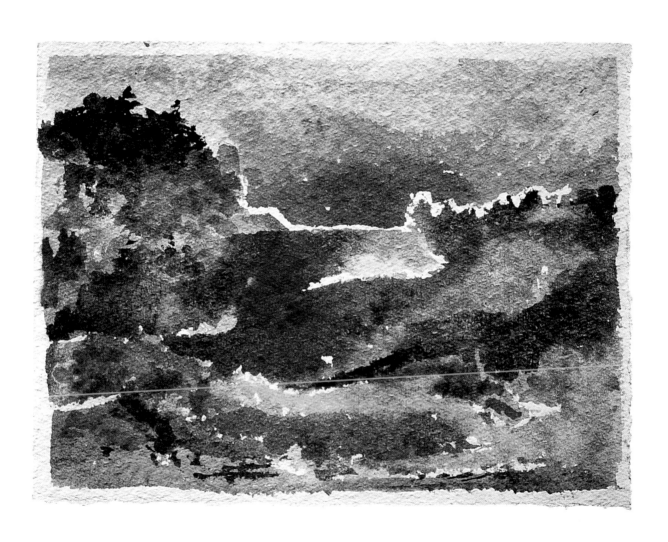

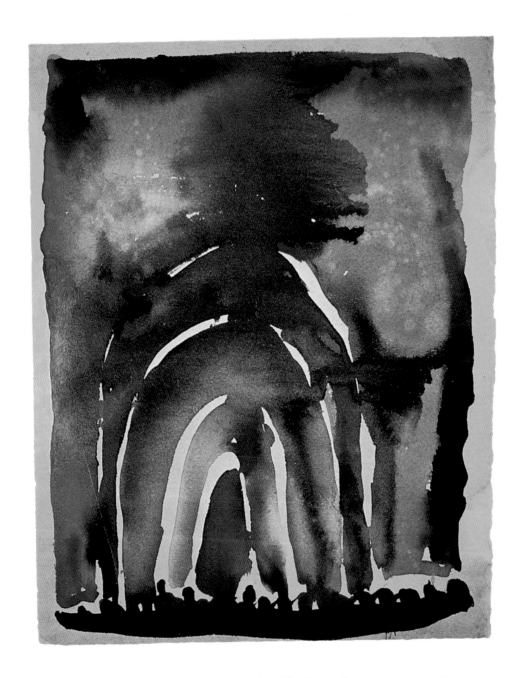

first light coming on the plains

the plains—the wonderful great
big sky—makes me want to
breath so deep that I'll
break—There is so much
of it—I want to get outside
of it all—I would if I
could—even if it
killed me—

■■■■

GEORGIA O'KEEFFE
TO ALFRED STIEGLITZ
Canyon, Texas, 1916

...**colors** *are used not because they are true to nature,*
but because they are necessary to the
particular picture. In fact, the artist is not
only justified in using, but it is his duty
to use only those forms which fulfill
his own need. Absolute freedom, whether
from anatomy or anything of the kind,
must be given the artist in his choice of
material. Such spiritual freedom is
as necessary in art as it is in life.

WASSILY KANDINSKY

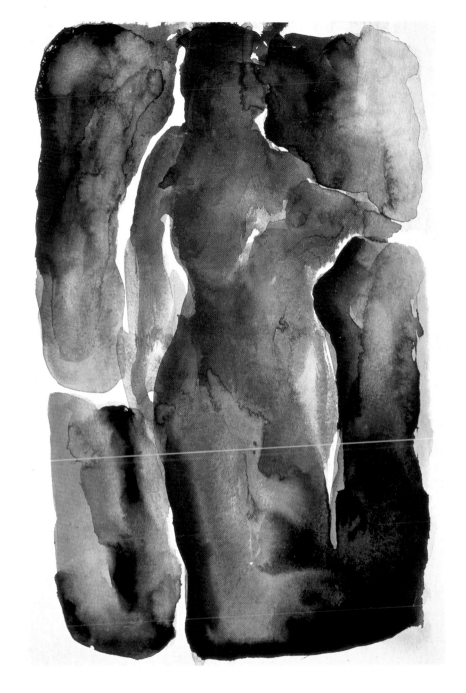

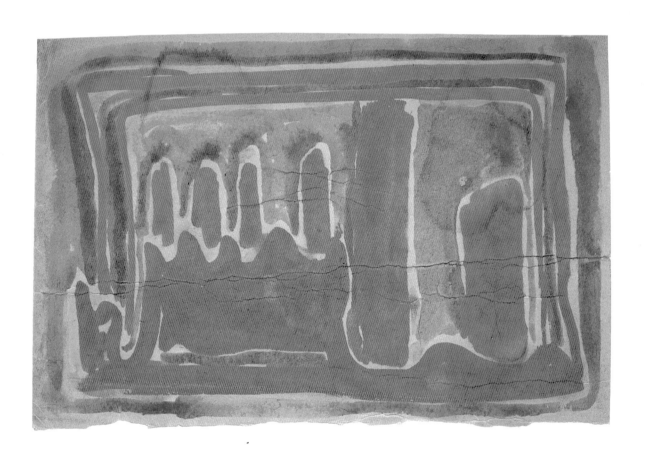

——

I realized that I had things in my head not like what I had
been taught—not like what I had seen—shapes and ideas so familiar
to me that it hadn't occurred to me to put them down.
I decided to stop painting, to put away everything I had done,
and to start to say the things that were

my own.

This was one of the best times in my life. There was no one around
to look at what I was doing—no one interested—no one to
say anything about it one way or another. I was alone and singularly
free, working on my own, unknown—no one to satisfy but myself.

GEORGIA O'KEEFFE

——

abstraction, pink and green

In praise of the puffball

The puffball appears on the hill
like the brain of an angel,
full of itself yet modest,
where it sprang like a pearl
from the dark fingers of space
and the ring where light years ago

it clustered unnoticed,
a gleam in the brim of Saturn,

a moon as homely as soap,
scrubbed by solar winds
and the long shadows of stars
and the smoke of dead cities
and the muscles of the tide
and the whorled oil of our thumbs,
and the earth, pleased to make room
for this pale guest, darkening.

NANCY WILLARD

blue hills

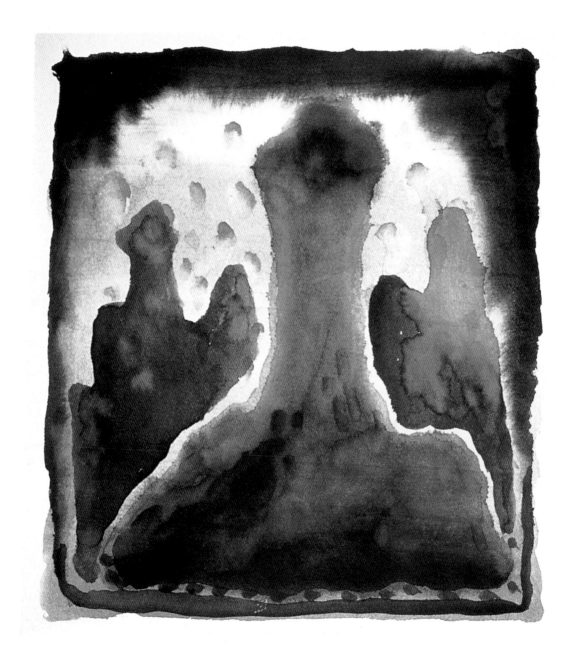

i

wish you could see the landscapes I painted last Monday out where the canyon begins . . . You possibly remember that my landscapes are always funny and these are not exceptions—Slits in nothingness are not very easy to paint—but it's great to try—I'm going again Monday if it isn't too windy. . .

———

GEORGIA O'KEEFFE TO ANITA POLLITZER

Canyon, Texas, October 1916

abstraction, dark

WALKING WEST

Anyone with a quiet pace who
walks a gray road in the West
may hear a badger underground where
in deep flint another time is

Caught by flint and held forever,
the quiet pace of God stopped still.
Anyone who listens walks on
time that dogs him single file,

To mountains that are far from people,
the face of the land gone gray like flint.
Badgers dig their little lives there,
quiet-paced the land lies gaunt,

The railroad dies by a yellow depot,
town falls away toward a muddy creek.
Badger-gray the sod goes under
a river of wind, a hawk on a stick.

——

WILLIAM STAFFORD

grey abstraction (train in the desert)

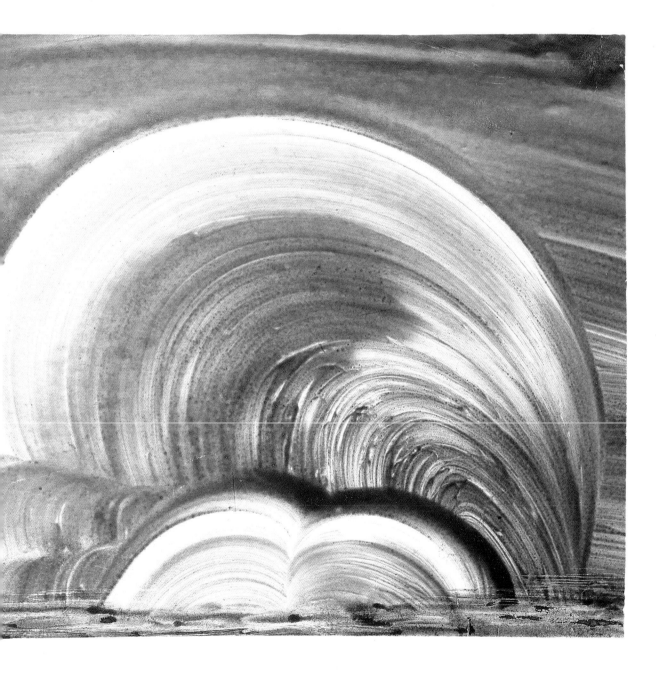

I've sat here a long
time—a dog
barking—The night
very still—a
train way off rumbling
and humming
I've heard it a long
time—I don't
know whether it is
coming or going.

I guess it's coming.

———

GEORGIA O'KEEFFE
TO ELIZABETH STIEGLITZ
Canyon, Texas, January 1918

train coming in

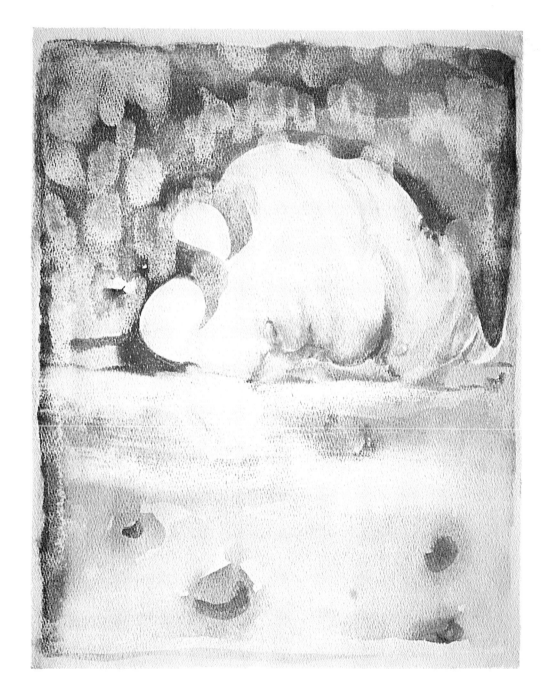

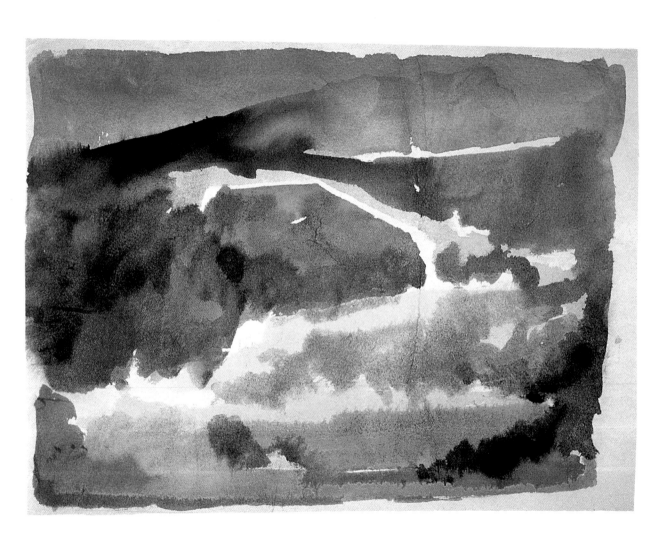

H

ad not the land entered their souls
and shaped their moods into
permanent or impermanent forms?
Less a thought than a feeling;
but she went on more
rapidly toward the complete joy
of the moment
in which she lived.

ELLEN GLASGOW

landscape

I used to love to drift along

the pale-yellow cornfield, looking for the damp spots one

sometimes found at their edges, where the smartweed

soon turned a rich copper color and the narrow brown leaves

hung curled like cocoons about the swollen joints of the

stem. Sometimes I went south to visit our German neighbors and to

admire their catalpa grove, or to see the big elm tree that grew

up out of a deep crack in the earth and had a

hawk's nest in its branches. Trees were so rare in that country,

and they had to make such a hard fight to grow,

that we used to feel anxious about them, and visit them

as if they were persons. It must have been the scarcity of detail in

the tawny landscape that made detail so precious.

———

WILLA CATHER

tree

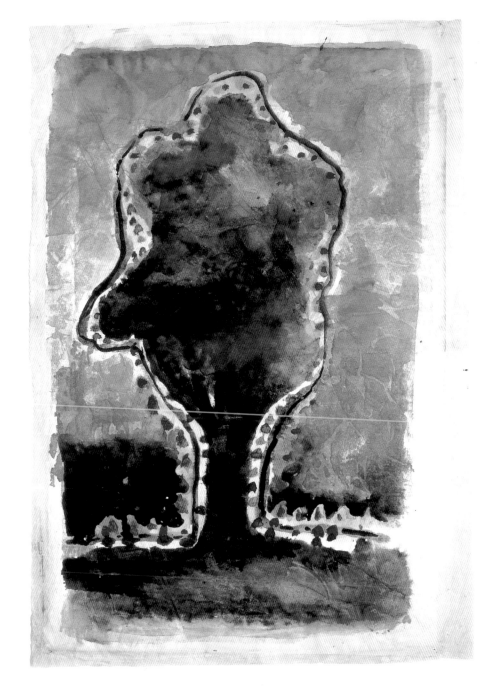

45

T here are flame tones,—almost savage reds to verify the flesh—greys of whatever hue that seek to modify them of too much animal assertion—there are disconsolate hues of ash-like resignation, all of which typify the surging passion of a nature seeking by expression first of all to satisfy herself— and in the end perhaps to satisfy those agencies of sensation and emotion that pursue and demand deliverance.

MARSDEN HARTLEY

abstraction, green and red

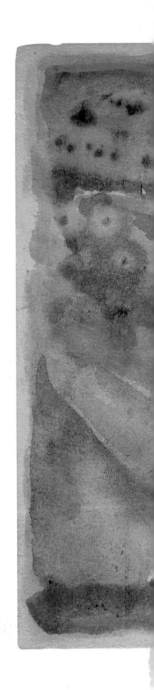

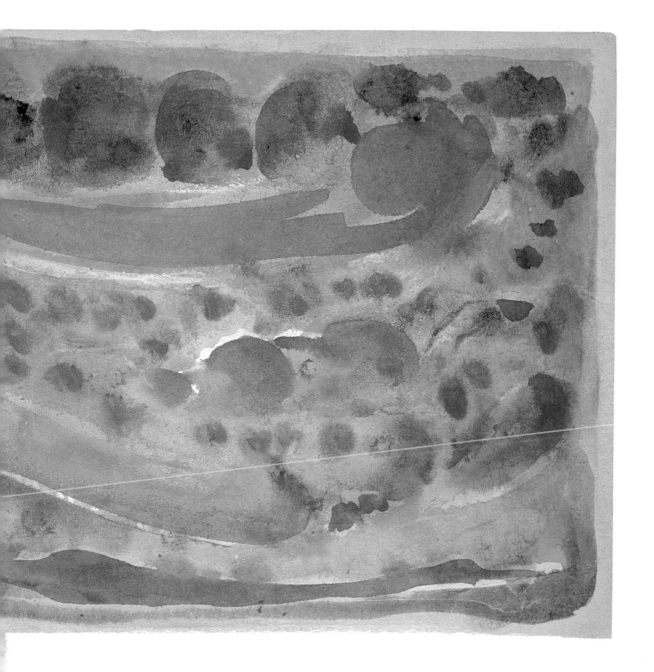

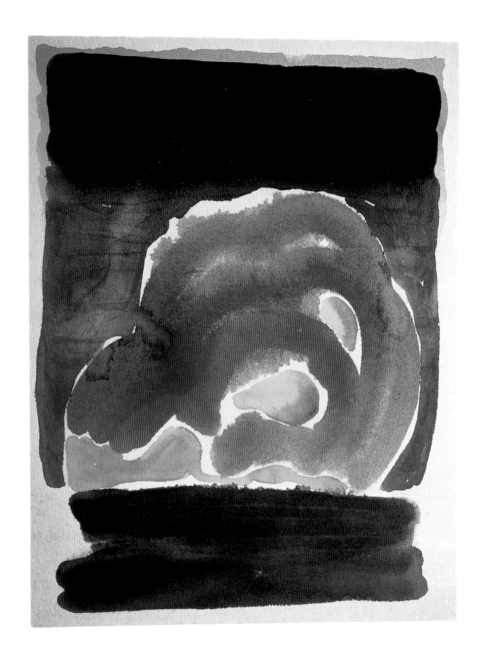

level light

Sometimes the light when evening fails
stains all haystacked country and hills,
runs the cornrows and clasps the barn
with that kind of color escaped from corn
that brings to autumn the winter word—
a level shaft that tells the world:

It is too late now for earlier ways;
now there are only some other ways,
and only one way to find them—fail.

In one stride night then takes the hill.

———

WILLIAM STAFFORD

evening

I would not forget the rocky hills studded with giant cactus, the secret canyons winding into unknown places, the purple, shadowed mountains on the horizon, the rich complex of animal life, bird life, plant life, all that strange, sometimes bitter magic of the natural world. I knew that I would be back, many times.

EDWARD ABBEY

purple mountains

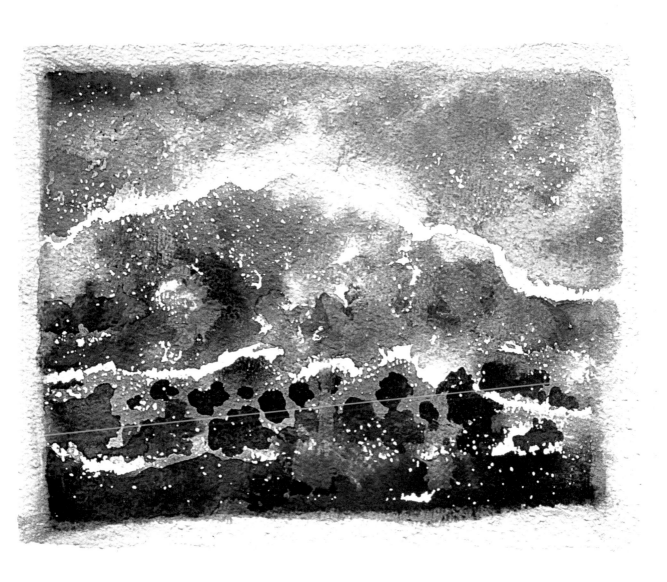

The sky was as full of motion and

change as the desert beneath it was monotonous

and still—and there was so much sky, more than at sea,

more than anywhere else in the world. The plain

was there, under one's feet, but what one saw

when one looked about was that

brilliant blue world

of sinking air and moving cloud.

Even the mountains were mere ant-hills under it.

Elsewhere the sky is the roof of the world;

but here the earth was the floor of the sky. The landscape

one longed for when one was far away,

the thing all about one, the world one actually

lived in, was the sky, the sky!

———

WILLA CATHER

light coming on the plains

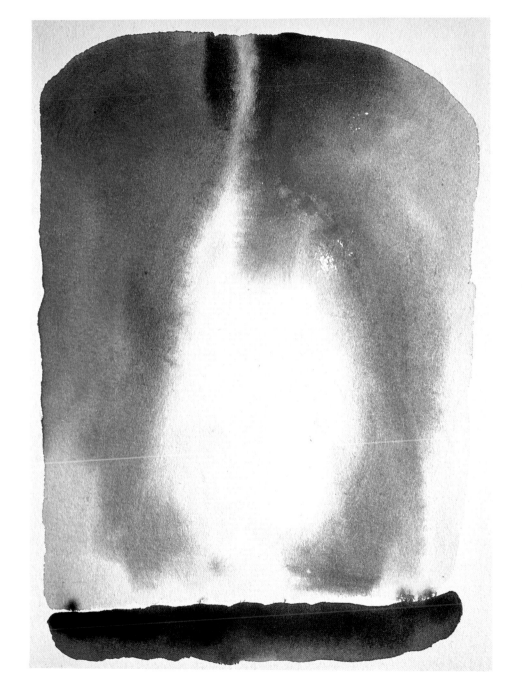

53

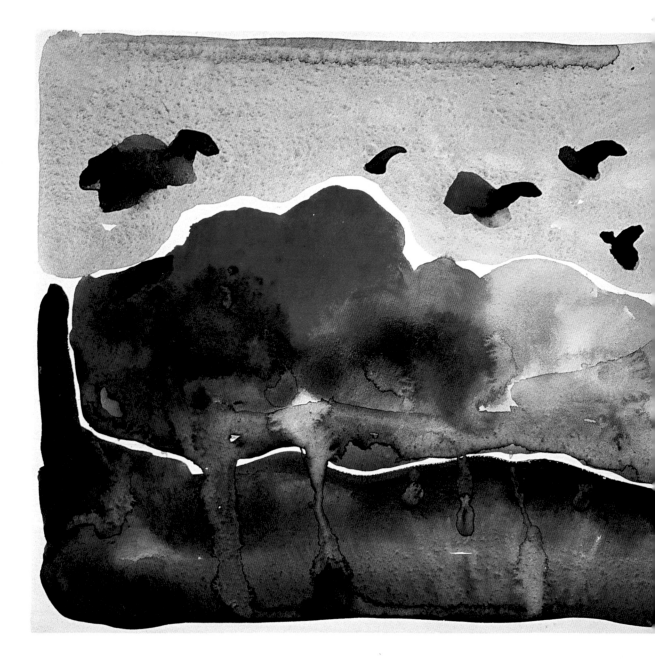

There is something sweet,
calming and benign
in the general stillness,
a quiet never disturbed by
any sounds more harsh
than those of the wind
rushing through
the tall grass,
the music
of falling water,
the scream
of a hawk.

EDWARD ABBEY

landscape with crows

... the lightning broke in great zigzags across the heaven, making everything stand out and come close to us for a moment. Half the sky was checkered with black thunderheads, but all the west was luminous and clear: in the lightning flashes it looked like deep blue water, with the sheen of moonlight on it; and the mottled part of the sky was like marble pavement, like the quay of some splendid sea-coast city, doomed to destruction.

WILLA CATHER

The Eastern sky was all grey blue—bunches of clouds—different kinds of clouds—sticking around everywhere and the whole thing—lit up— first in one place—then in another with flashes of lightning—sometimes just sheet lightning—and sometimes sheet lightning with a sharp bright zigzag flash across it—.

GEORGIA O'KEEFFE TO ALFRED STIEGLITZ
Canyon, Texas, September 1916

abstraction, black and blue

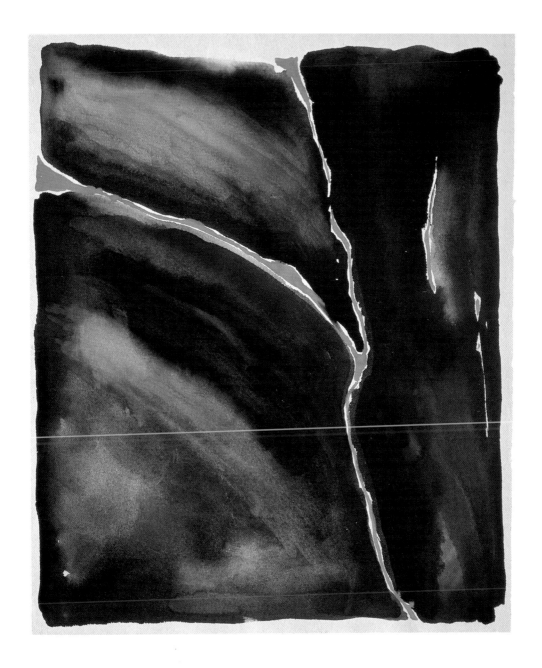

Sunday morning—a little breeze—cool feeling air—very hot sun—such

a nice quiet feeling morning—strips of green—blue green—

pale hazy—almost unbelievably beautiful—out of my window—it

startled me when I first saw it—it isn't often hazy here.

———

GEORGIA O'KEEFFE TO PAUL STRAND
Canyon, Texas, June 1917

sunrise II

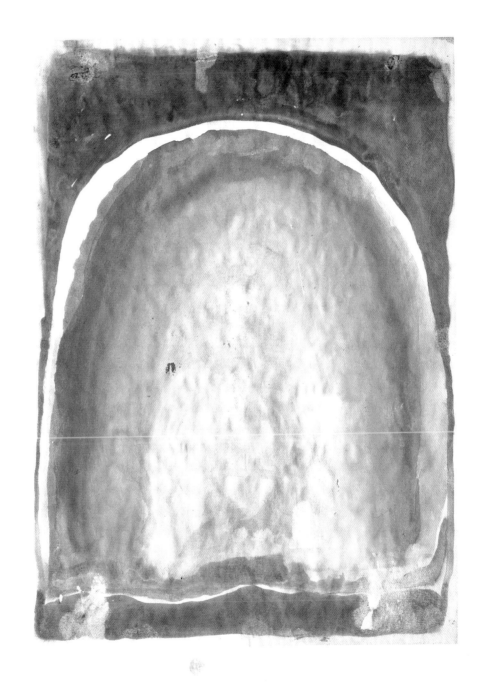

*I*t was one of those still days of intense light, when every particle of mica in the soil flashed like a little mirror, and the glare from the plain below seemed more intense than the rays from above. The sand ridges ran glittering gold out to where the mirage licked them up, shining and steaming like a lake in the tropics. The sky looked like blue lava, forever incapable of clouds—a turquoise bowl that was the lid of the desert.

WILLA CATHER

across the plains

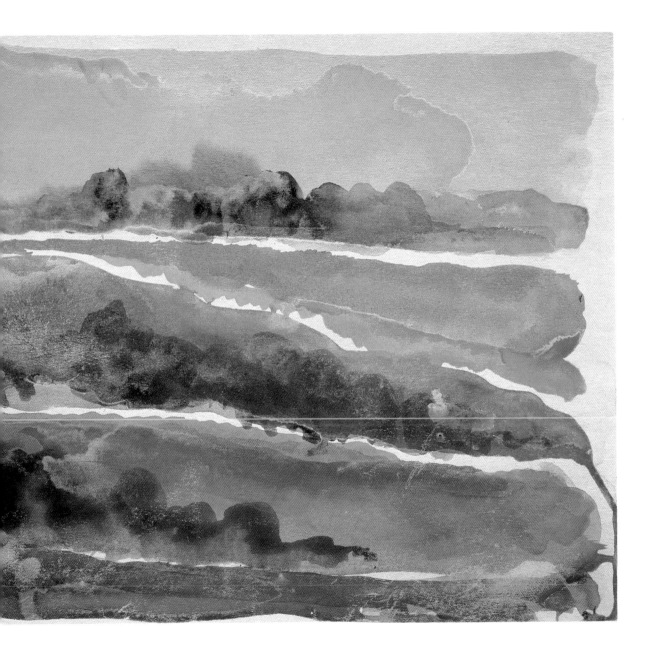

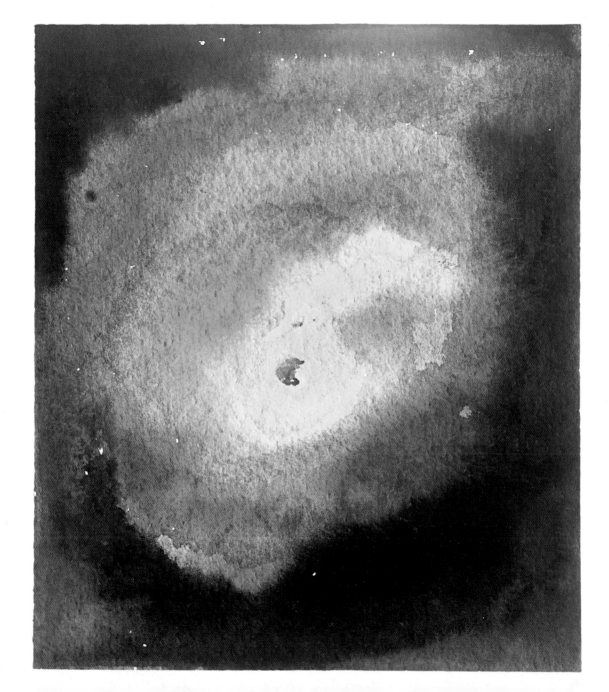

NOTHING HAPPENED. I didn't expect anything to happen. I was something that lay under the sun and felt it, like the pumpkins, and I did not want to be anything more. I was entirely happy. Perhaps we feel like that when we die and become a part of something entire, whether it is sun and air, or goodness and knowledge. At any rate, that is happiness; to be dissolved into something complete and great. When it comes to one, it comes as naturally as sleep.

WILLA CATHER

THE CLIFF

Below me, treetops, a crow
making its slow progress.
The green canopy's no sea
or net, but that absolute—
thin veil between
the living and the dead.

Confusion of thickets behind me;
before me, open space.

From time to time returning
to this granite ledge
where I measure my life
by refusals, here
where measuring starts,
less than a step from the edge.

GREGORY ORR

canyon landscape

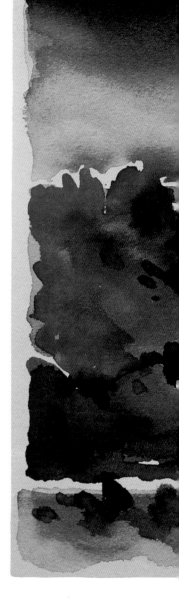

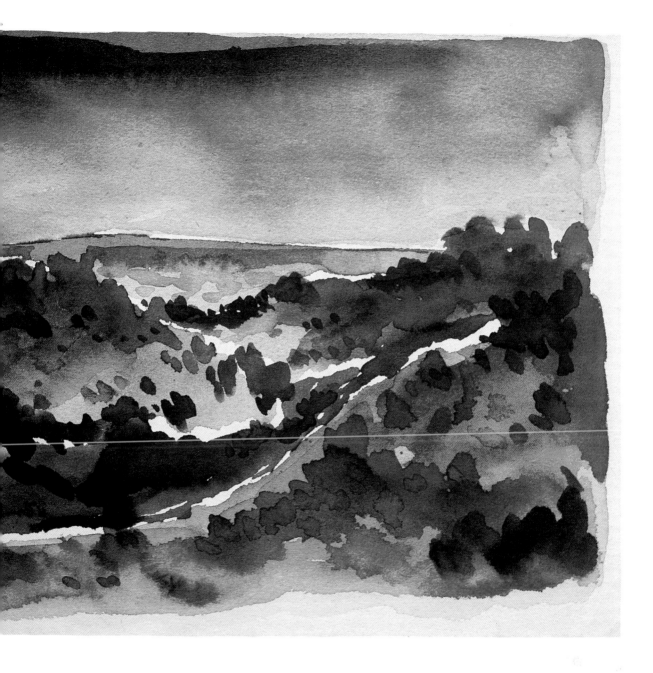

We sat looking off across the country, watching the

sun go down. The curly grass about

us was on fire now. The bark of the oaks turned

red as copper. There was a shimmer of gold on the born river.

Out in the stream the sandbars glittered like glass, and

the light trembled in the willow thickets

as if little flames were leaping among them.

The breeze sank to stillness. In the ravine a ringdove

mourned plaintively, and somewhere off in the

bushes an owl hooted.

WILLA CATHER

dusk in the canyon

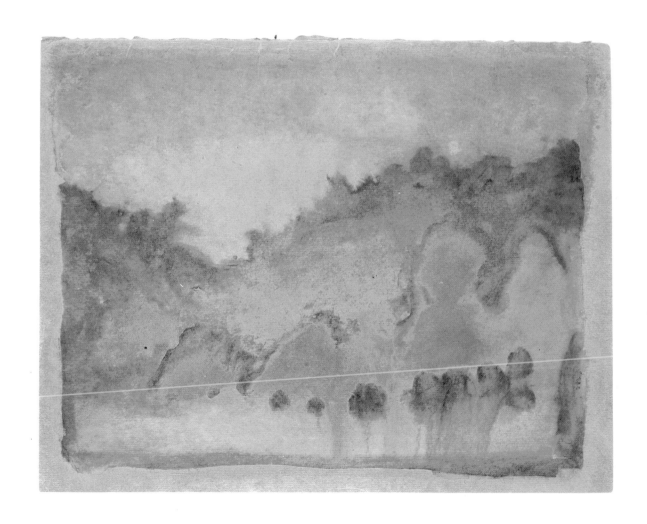

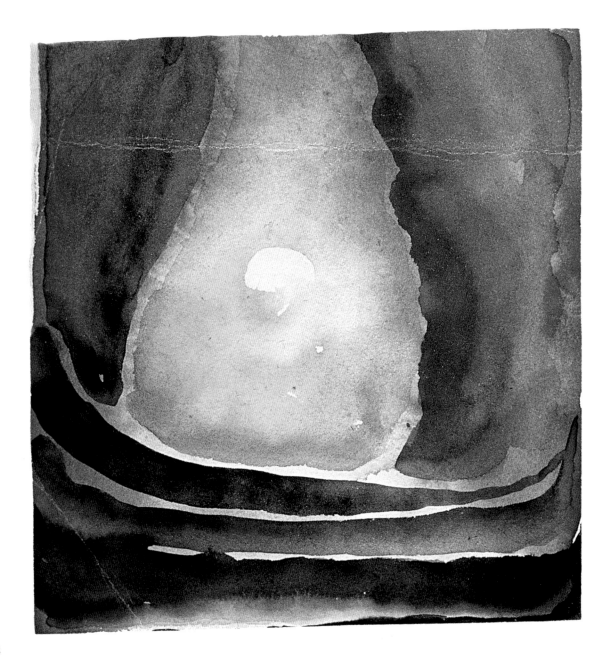

sunrise I

———

The air would disappear from the whole earth in time, perhaps;

but long after his day. He did not know just when it

had become so necessary to him, but he had come back to die in exile

for the sake of it. Something soft and wild and free, something that

whispered to the ear

on the pillow, lightened the heart, softly, softly picked the lock, slid the bolts,

and released the prisoned spirit of man into the

wind, into the blue and gold, into the morning, into the morning!

———

WILLA CATHER

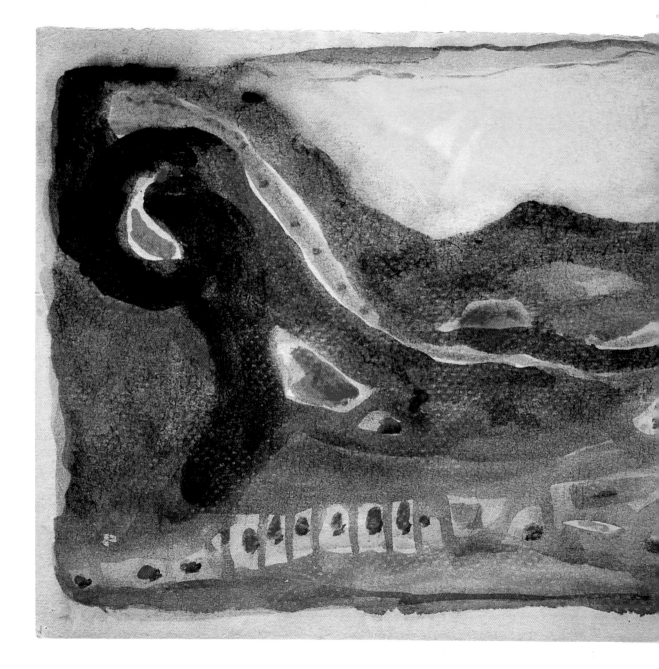

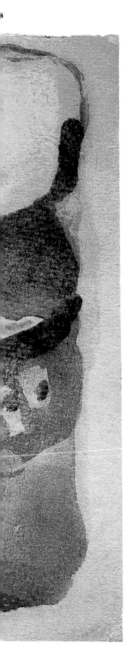

But it's all still

there in my heart and soul.

The walk, the hills, the sky, the solitary

pain and pleasure—they will grow

larger, sweeter, lovelier

in the days and years to come,

like a treasure found

and then, voluntarily,

surrendered.

Returned to the mountains

with my blessing.

It leaves a golden glowing

on the mind.

▬

EDWARD ABBEY

abstraction

Now

Where we live, the teakettle whistles out
its heart. Fern arrives to
batter the window. Every day gets lost
in a stray sunset and little touches of air.
Someone opens a door. It is this year.

We hear crickets compute their brittle
almanac. A friend or a stranger
comes to the door; it is always "Hello" again,
but just a friend or a stranger.
We get up and look out: a good year?

God knows. People we meet look older.
They ask how we are. It is this year.

▬▬▬

WILLIAM STAFFORD

red house with fence and door

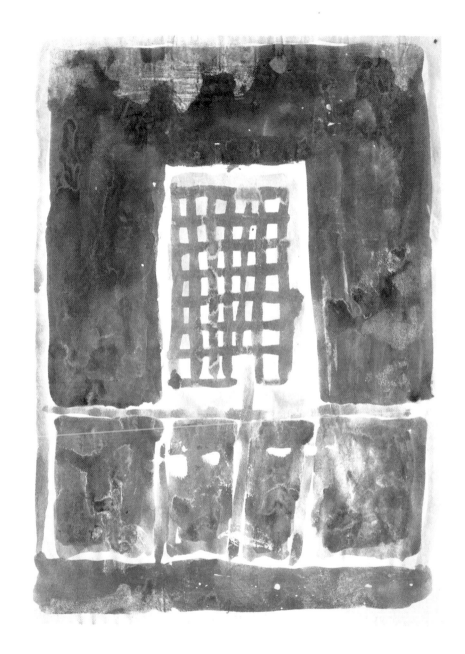

I... fall like the stone into a sea of sleep. The last thing I remember is a splendid meteor, gold fading into violet as it floats across the sky.

EDWARD ABBEY

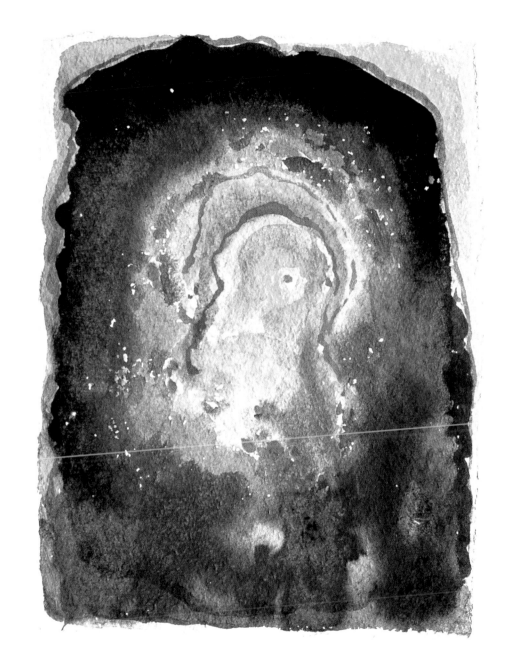

suggested readings

BOOKS

Abbey, Edward. *Beyond the Wall: Essays from the Outside*. New York: Henry Holt and Company, Inc., 1994.

_____. *Cactus Country: An American Wilderness*. New York: Time-Life Books, 1973.

Bry, Doris, ed. *Georgia O'Keeffe, Some Memories of Drawing*. Albuquerque, New Mexico: University of New Mexico Press, 1974.

Cather, Willa. *Death Comes for the Archbishop*. 1927. New York: Vintage Books, a division of Random House, 1990.

_____. *My Ántonia*. 1918. Boston. Massachusetts: Houghton Mifflin Company, 1946.

_____. *The Song of the Lark*. 1915. New York: Signet Classic, Penguin Books, USA, 1991.

Cowart, Jack, and Juan Hamilton, eds., letters selected and annotated by Sarah Greenough, *Georgia O'Keeffe, Art and Letters*. Washington, D. C.: National Gallery of Art, in association with the New York Graphic Society Books, Little, Brown and Company, Boston, Massachusetts, 1988.

Dow, Arthur Wesley. *Composition, A Series of Exercises in Art Structure for the Use of Students and Teachers*. Garden City, New Jersey: Doubleday, Page & Company, 1923.

Glasgow, Ellen. *Barren Ground*. San Diego, California: Harcourt Brace & Company, 1933.

Kandinsky, Wassily. *Concerning the Spiritual in Art*, trans. M.T.H. Sadler. New York: Dover Publications, Inc., 1977.

Orr, Gregory. "The Cliff," in *Poems for a Small Planet: Contemporary Nature Poetry*, ed. Robert Pack and Jay Parini. Hanover, Vermont: Middlebury College Press, 1993.

Pollitzer, Anita. *A Woman on Paper: Georgia O'Keeffe*, introduction by Kay Boyle. New York: A Touchstone Book, published by Simon and Schuster, Inc., 1988.

Stafford, William. "Level Light," and "Now" in *Stories that Could Be True, New and Collected Poems*. New York: Harper & Row Publishers, 1977.

_____. "Walking West," in *The Rescued Year*. New York: Harper & Row Publishers, 1966.

Wilder, Mitchell A., ed. *Georgia O'Keeffe, An Exhibition of the Work of the Artist from 1915 to 1966*. Amon Carter Museum of Western Art, Fort Worth, Texas, March 17–May 9, 1966)

Willard, Nancy, "In Praise of the Puffball," in *Poems for a Small Planet: Contemporary Nature Poetry*, ed. Robert Pack and Jay Parini. Hanover, Vermont: Middlebury College Press, 1993.

MANUSCRIPT SOURCES

The Alfred Stieglitz/Georgia O'Keeffe Archive, Yale Collection of American Literature, Beinecke Rare Book and Manuscript Library [YCAL MSS 85], Series VII, Personal and Business Correspondence, Box 209, Folder 3653.

The Flora Stieglitz Straus Collection of Stieglitz Family Papers, Yale Collection of American Literature, Beinecke Rare Book and Manuscript Library [YCAL MSS 89], Box, 3, Folder 65.

notes

INTRODUCTION

1. Roxanna Robinson, *Georgia O'Keeffe, A Life* (New York: Harper Perennial, 1990), 27.
2. Robinson, *Georgia O'Keeffe*, 47.
3. Lloyd Goodrich and Doris Bry, *Georgia O'Keeffe* (New York: Whitney Museum of American Art, Praeger Publishers, 1970), 8.
4. Barbara Novak, *Nature and Culture: American Landscape and Painting, 1825-1975* (New York: Oxford University Press, 1980), 78.
5. Arthur Wesley Dow, *Composition: A Series of Exercises in Art Structure for the Use of Students and Teachers* (Garden City, New York: Doubleday, Page and Company, 1923), 50.
6. T. J. Clark, *The Painting of Modern Life, Paris in the Art of Manet and His Followers* (Princeton, New Jersey: Princeton University Press, 1984), 4.
7. Goodrich and Bry, *Georgia O'Keeffe*, 9.
8. Sarah Greenough, "From the Faraway," in *Georgia O'Keeffe, Art and Letters*, ed. Jack Cowart, Juan Hamilton, letters selected and annotated by Sarah Greenough, (Washington, D.C.: National Gallery of Art, in association with New York Graphic Society Books, Little, Brown and Company, Boston, 1987), 135.
9. Willa Cather, *Death Comes for the Archbishop* (New York: Alfred A. Knopf, Inc., 1927; New York: Vintage Books, 1971), 231–32.
10. Greenough, 157.
11. Willa Cather, *My Ántonia*, 1918 (Boston, MA: Houghton Mifflin Company, 1988), 89.
12. Greenough, 157.
13. Doris Grumbach, Foreword, *My Ántonia*, x.
14. Ruby Cole Archer, interview with Al Koschka, Amarillo Art Center, in Robinson, 159.
15. Grumbach, Foreward, *My Ántonia*, xi.
16. Willa Cather, in *Lincoln State Journal*, Nov. 2, 1921, in Robinson, 189–90.
17. Robinson, p. 190.
18. Edward Abbey, *Beyond the Wall, Essays from the Outside* (New York: Henry Holt and Company, 1971/84), 47-8.
19. According to Barbara Novak in *Nature and Culture: American Landscape and Painting, 1825–1875*, "In the early nineteenth century in America, nature couldn't do without God and God apparently couldn't do without nature. By the time Emerson wrote *Nature* in 1836, the terms 'God' and 'nature' were often the same thing, and could be used interchangeably. The transcendentalists accepted God's immanence." 3.
20. Novak, *Nature and Culture*, 7.
21. Charles C. Eldredge, "Nature Symbolized: American Painting From Ryder to Hartley," in *The Spiritual in Art: Abstract Painting 1890–1985*, Los Angeles County Museum of Art, exhibition organized by Maurice Tuchman, editor, Edward Weisberger (New York: Abbeville Press Publishers, 1986), 116.
22. Wassily Kandinsky, *Concerning the Spiritual in Art*, M.T.H. Sadler, trans. (New York: Dover Publications, Inc. 1977), 50.
23. Eldredge, "Nature Symbolized," 124.

PAINTINGS AND QUOTATIONS

All of the works are in the collection of the Kemper Museum of Contemporary Art & Design, Kansas City, MO.

Alfred Stieglitz (1864–1946)
Portrait of Georgia O'Keeffe, 1920
vintage gelatin silver print
4 1/2 x 3 1/2 inches
Courtesy of the Enid and Crosby Kemper Foundation, L94:KF21.2.

Portrait—W
watercolor on paper
11 x 8 1/2 inches
Bebe and Crosby Kemper Collection
Gift of the William T. Kemper Charitable Trust, 1996.51.

Wassily Kandinsky, *Concerning the Spiritual in Art*, trans. M.T.H. Sadler (New York: Dover Publications, Inc., 1977), 32.

Dark Mesa
watercolor on paper
9 x 11 3/4 inches
Bebe and Crosby Kemper Collection
Gift of the William T. Kemper Charitable Trust, 1996.43.

Willa Cather, *Death Comes for the Archbishop* (New York: Alfred A. Knopf, 1927; New York: Vintage Books, a division of Random House, 1990), 94-95.

Sunset
watercolor on paper
11 1/2 x 8 inches
Bebe and Crosby Kemper Collection
Gift of Mr. and Mrs. R. Crosby Kemper, Jr, 1996.6.

Arthur Wesley Dow, *Composition, A Series of Exercises in Art Structure for the Use of Students and Teachers* (Garden City, NJ: Doubleday, Page & Company, 1923), 109.

First Light Coming on the Plains
watercolor on paper
12 1/2 x 9 1/2 inches
Bebe and Crosby Kemper Collection

Gift of the Enid and Crosby Kemper Foundation, 1996.36.

Jack Cowart and Juan Hamilton, eds., letters selected and annotated by Sarah Greenough, *Georgia O'Keeffe, Art and Letters* (Washington, DC: National Gallery of Art, in association with New York Graphic Society Books, Little, Brown and Company, Boston, 1988), 155.

Autumn on the Plains
watercolor on paper
11 1/4 x 15 inches
Bebe and Crosby Kemper Collection
Gift of the William T. Kemper Charitable Trust, 1996.47.

The Alfred Stieglitz/Georgia O'Keeffe Archive, Yale Collection of American Literature, Beinecke Rare Book and Manuscript Library [YCAL MSS 85], Series VII, Personal and Business Correspondence, Box 209, Folder 3653.

Standing Nude
watercolor on paper
12 x 8 inches
Bebe and Crosby Kemper Collection
Gift of Mr. and Mrs. R. Crosby Kemper, Jr.,1996.4.

Kandinsky, 53.

Abstraction, Pink and Green
watercolor on paper
7 x 10 1/2 inches
Bebe and Crosby Kemper Collection
Gift of the Enid and Crosby Kemper Foundation, 1996.40.

Doris Bry, ed., *Georgia O'Keeffe, Some Memories of Drawing* (Albuquerque, NM: University of New Mexico Press, 1974), np.

Blue Hills
watercolor on paper
8 3/4 x 11 inches
Gift of Mr. and Mrs. Gerald P. Peters,

Santa Fe, NM, 1996.54.

Nancy Willard, "In Praise of the Puffball," in Robert Pack and Jay Parini, eds., *Poems for a Small Planet: Contemporary Nature Poetry* (Hanover, VT: Middlebury College Press, 1993), 261-262.

Abstraction, Dark
watercolor on paper
11 1/4 x 10 1/4 inches
Gift of Mr. and Mrs. Gerald P. Peters, Santa Fe, NM, 1996.55.

The Alfred Stieglitz/Georgia O'Keeffe Archive.

Grey Abstraction (Train in the Desert)
watercolor on paper
9 1/2 x 12 1/4 inches
Bebe and Crosby Kemper Collection
Gift of Mr. and Mrs. R. Crosby Kemper, Jr., 1996.5.

William Stafford, "Walking West," in *The Rescued Year* (New York: Harper & Row, Publishers, 1966), 47.

Train Coming In
watercolor on paper
14 x 11 inches
Gift of Mr. and Mrs. Gerald P. Peters, Santa Fe, NM, 1996.57.

The Flora Stieglitz Straus Collection of Stieglitz Family Papers, Yale Collection of American Literature, Beinecke Rare Book and Manuscript Library [YCAL MSS 89], Box 3, Folder 65.

Landscape
watercolor on paper
8 1/2 x 11 1/2 inches
Bebe and Crosby Kemper Collection
Gift of the Enid and Crosby Kemper Foundation, 1996.38.

Ellen Glasgow, *Barren Ground* (San Diego, CA: Harcourt Brace & Company, 1933), 128.

Tree
watercolor on paper
15 1/4 x 10 3/4 inches
Bebe and Crosby Kemper Collection
Gift of the William T. Kemper Charitable
Trust, 1996.50.

Willa Cather, *My Ántonia*, 1918 (Boston,
MA: Houghton Mifflin Company, 1946), 21.

Abstraction, Green and Red
watercolor on paper
9 1/2 x 12 1/2 inches
Bebe and Crosby Kemper Collection
Gift of the Enid and Crosby Kemper
Foundation, 1996.41.

Marsden Hartley, as quoted in Wilder,
Mitchell A., ed., *Georgia O'Keeffe, An
Exhibition of the Work of the Artist From
1915-1966*, Amon Carter Museum of
Western Art, Fort Worth, TX, March 17-
May 9, 1966.6.

Evening
watercolor on paper
11 1/2 x 8 1/2 inches
Bebe and Crosby Kemper Collection
Gift of the Enid and Crosby Kemper
Foundation, 1996.52.

William Stafford, "Level Light," in *Stories
That Could Be True, New and Collected
Poems* (New York: Harper & Row
Publishers, 1977), 50.

Purple Mountains
watercolor on paper
9 1/2 x 12 1/4 inches
Bebe and Crosby Kemper Collection
Gift of the William T. Kemper Charitable
Trust, 1996.46.

Edward Abbey, *Cactus Country: An
American Wilderness* (New York: Time-Life
Books, 1973), 27.

Light Coming on the Plains
watercolor on paper
12 1/2 x 9 inches
Bebe and Crosby Kemper Collection
Gift of Mr. and Mrs. R. Crosby Kemper,
Jr., 1996.8.

Cather, *Death Comes For the Archbishop*,
231-232.

Landscape with Crows
watercolor on paper
7 1/2 x 11 inches
Bebe and Crosby Kemper Collection
Gift of Mr. and Mrs. R. Crosby Kemper,
Jr., 1996.9.

Abbey, *Cactus Country*, 77.

Abstraction, Black and Blue
watercolor on paper
12 1/4 x 10 1/4 inches
Bebe and Crosby Kemper Collection
Gift of Mr. and Mr. R. Crosby Kemper, Jr.,
1996.7.

Cather, *My Ántonia*, 89.

Cowart and Hamilton, 155.

Sunrise II
watercolor on paper
10 1/2 x 7 1/2 inches
Bebe and Crosby Kemper Collection
Gift of the Enid and Crosby Kemper
Foundation, 1996.37.

Cowart and Hamilton, 163.

Across the Plains
watercolor on paper
10 1/4 x 14 1/2 inches
Bebe and Crosby Kemper Collection
Gift of the Enid and Crosby Kemper
Foundation, 1996.48.

Willa Cather, *The Song of the Lark*, 1915
(New York: Signet Classic, Penguin Books,
USA, 1991), 65.

Abstraction, Sunset
watercolor on paper
10 3/4 x 9 1/2 inches
Bebe and Crosby Kemper Collection
Gift of the William T. Kemper Charitable
Trust, 1996.42.

Cather, *My Ántonia*, 14.

Canyon Landscape
watercolor on paper
9 x 12 1/4 inches

Bebe and Crosby Kemper Collection
Gift of the William T. Kemper Charitable
Trust, 1996.45.

Gregory Orr, "The Cliff," in Pack and
Parini, 163.

Dusk in the Canyon
watercolor on paper
8 1/2 x 11 1/4 inches
Bebe and Crosby Kemper Collection
Gift of the Enid and Crosby Kemper
Foundation, 1996.49.

Cather, *My Ántonia*, 155-156.

Sunrise I
watercolor on paper
7 3/4 x 7 1/2 inches
Bebe and Crosby Kemper Collection
Gift of the Enid and Crosby Kemper
Foundation, 1996.44.

Cather, *Death Comes for the Archbishop*,
273.

Abstraction
watercolor on paper
9 1/2 x 12 inches
Bebe and Crosby Kemper Collection
Gift of the William T. Kemper Charitable
Trust, 1996.39.

Edward Abbey, *Beyond the Wall: Essays
from the Outside* (New York: Henry Holt
and Company, Inc., 1994), 49.

Red House with Fence and Door
watercolor on paper
10 1/2 x 7 1/2 inches
Gift of Mr. and Mrs. Gerald P. Peters,
Santa Fe, NM, 1996.56.

Stafford, "Now," in *Stories That Could Be
True*, 243.

Abstraction
watercolor on paper
12 x 9 inches
Bebe and Crosby Kemper Collection
Gift of the William T. Kemper Charitable
Trust, 1996.53.

Abbey, *Beyond the Wall*, 47-48.